The Hotshot Music Show
Photography Collection
By Steve Presley
Peru Indiana
2015

This is a collections of photographs of my music show performed April to November 2015 in Peru Indiana at the corner of West 5th Street and North Broadway in front of a vacant lot, "The Presley Building". I call the show the Hotshot Music show meaning I am a hotshot performed who know what I am doing. I used a Martin D18 dreadnought acoustic guitar, a dark blue Fender Bullet electric guitar, Fender Mustang Mini type pr-11pp battery powered amp (set to 60s Twin Reverb), a DOD DFX-9 digital delay, a variety of harmonicas (M. Honer Blues Harp, Marine Band, Echo etc, in various keys) and white nylon .46 mm Jim Dunlop picks. This year I put on many costumes for enhanced visual appeal. Luckily a photographer, Terry Compton took photos of my show that I am using here. His shop is near where I did the shows. I dressed as a clown for him and his wife Marlee to get people to come into their store. She does art and sells her and others art in their store. I walked around the street carnival in July and on both sides of the circus parade holding a sign to visit their Miami County Artisan Gallery Store. The music show I do is for tips. I have a tin can on the sidewalk for tips. Here they are meager, from $20 to $100 for the eight months that I do the show. Acoustic music is country, folk, blues, gospel, and jazz. The electric music I do is rock, blues, and jazz. It is jazz influenced symphonic music. There are three to six movements with theme melodies that I weave in and out of. The show lasts an hour. I have played here since about 2002. I live three bocks to the east in my house. Years before I have traveled doing street music shows in the fifty United States, Canada many times, and Europe several times. Peru, Indiana has very few people walking by on the sidewalks and so I get very few tips. The population is about eleven thousand people. Large cities I have been to gave much more tips. I really do not do the show for the money. Mostly I do it for laughs, to entertain myself, and to get practice so I get to be a better musician. I like an audience and meeting new people. After I do a show, I get relaxed and sleep well at night.

HOTSHOT PICS

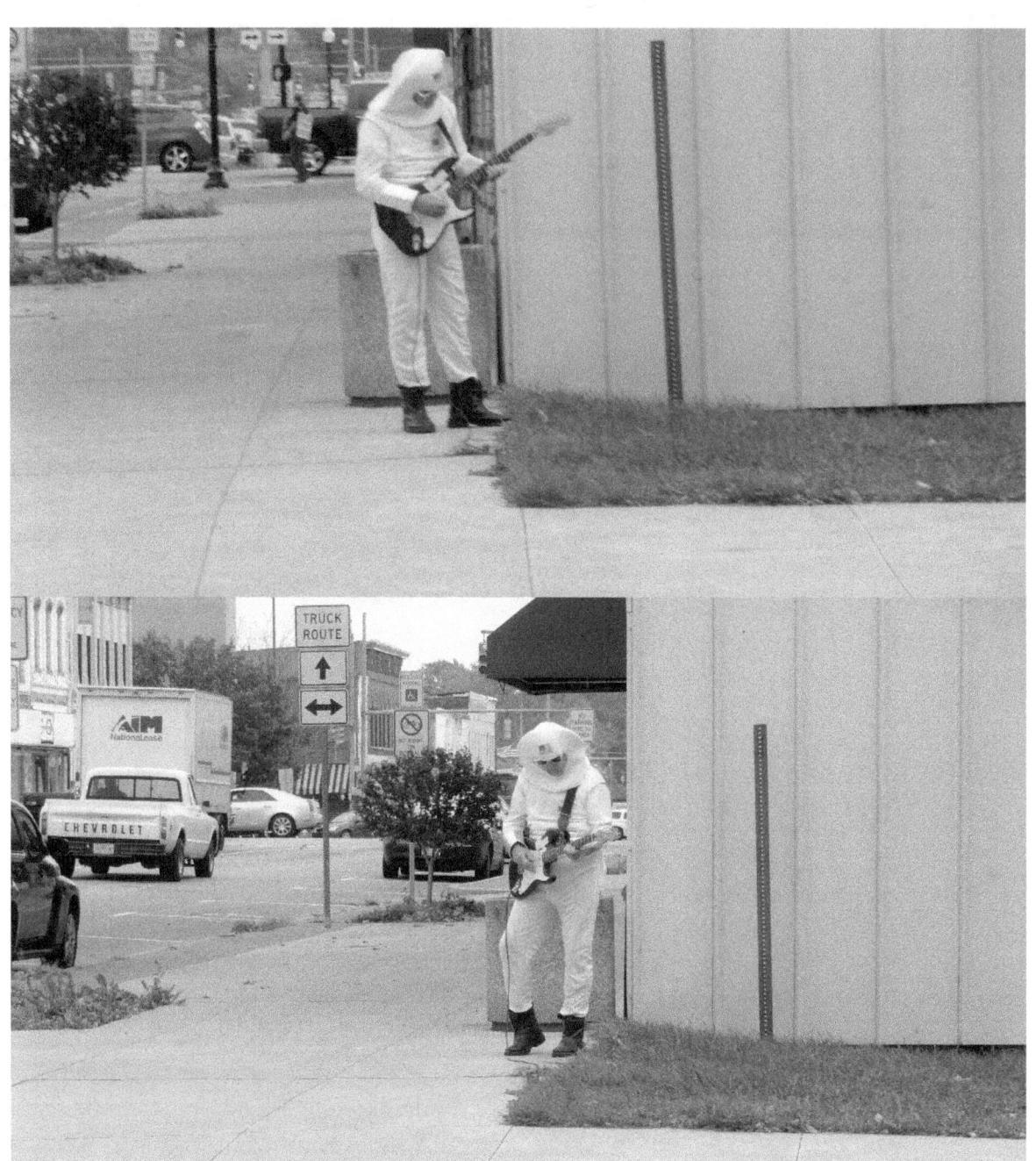

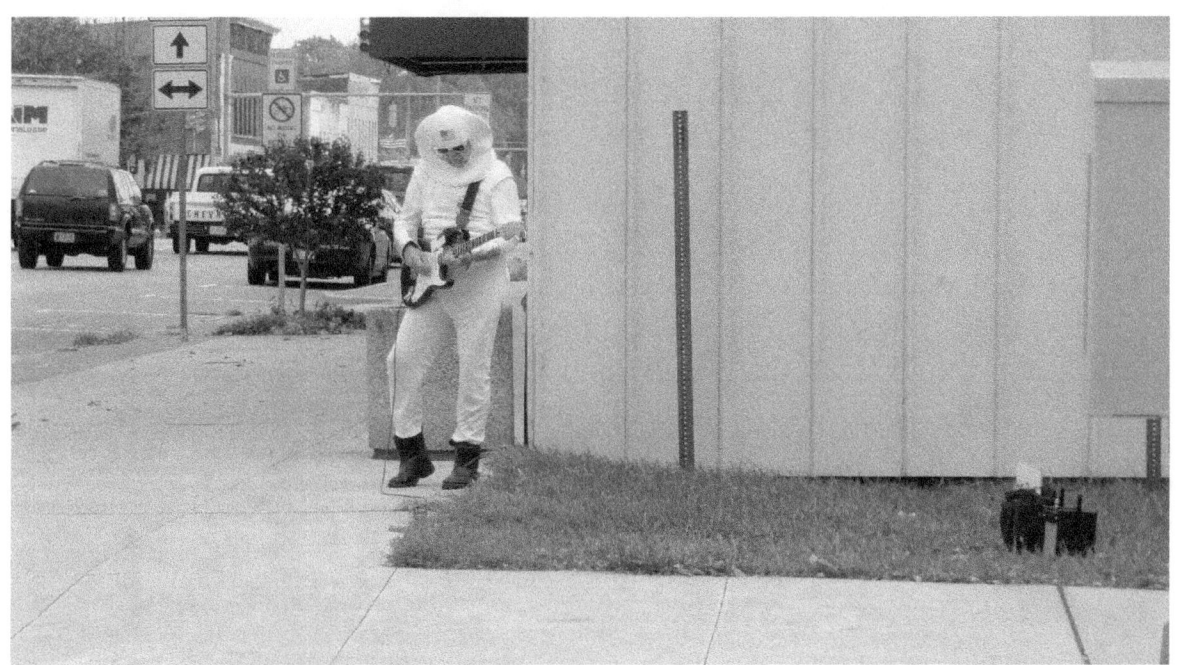

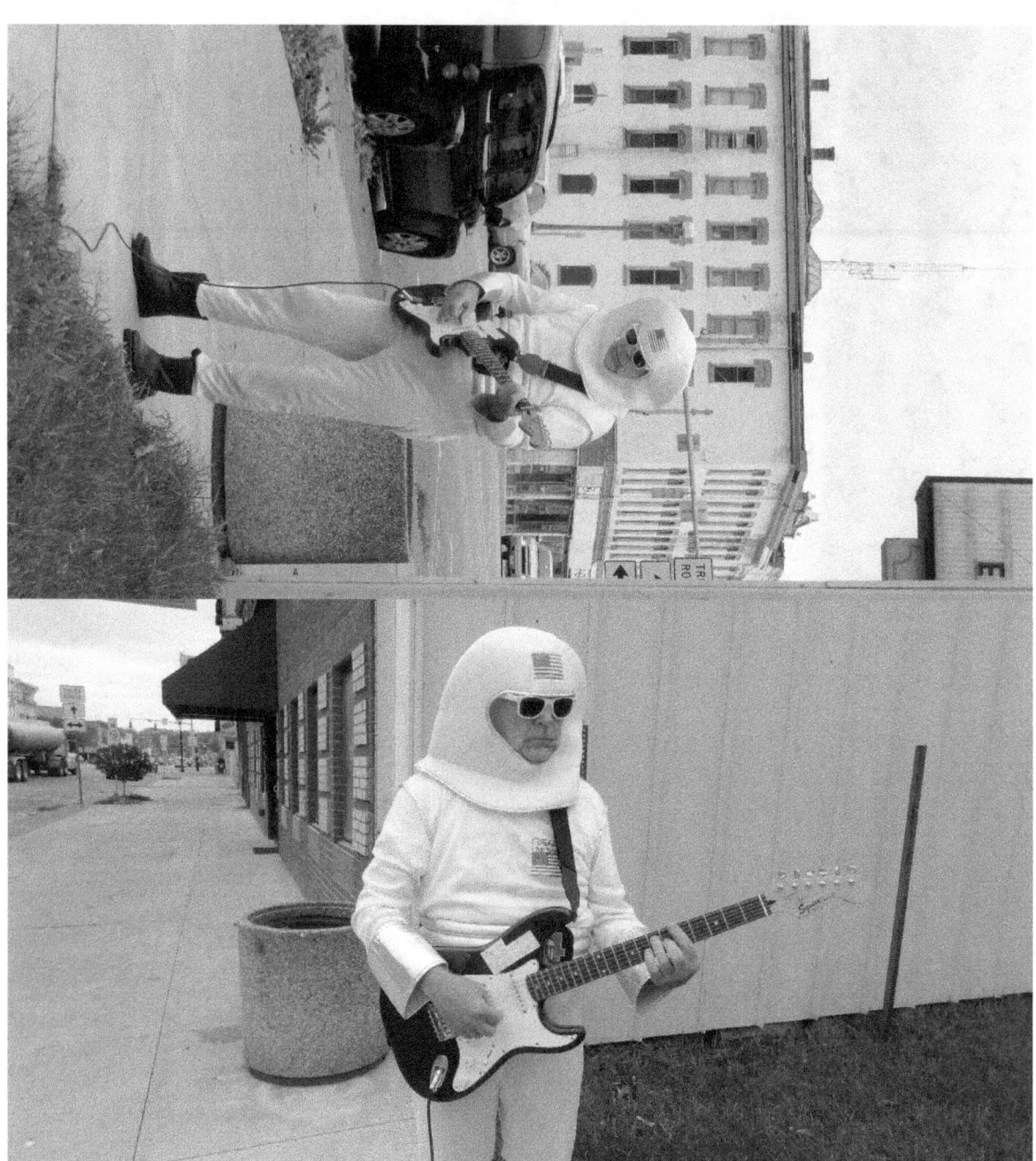

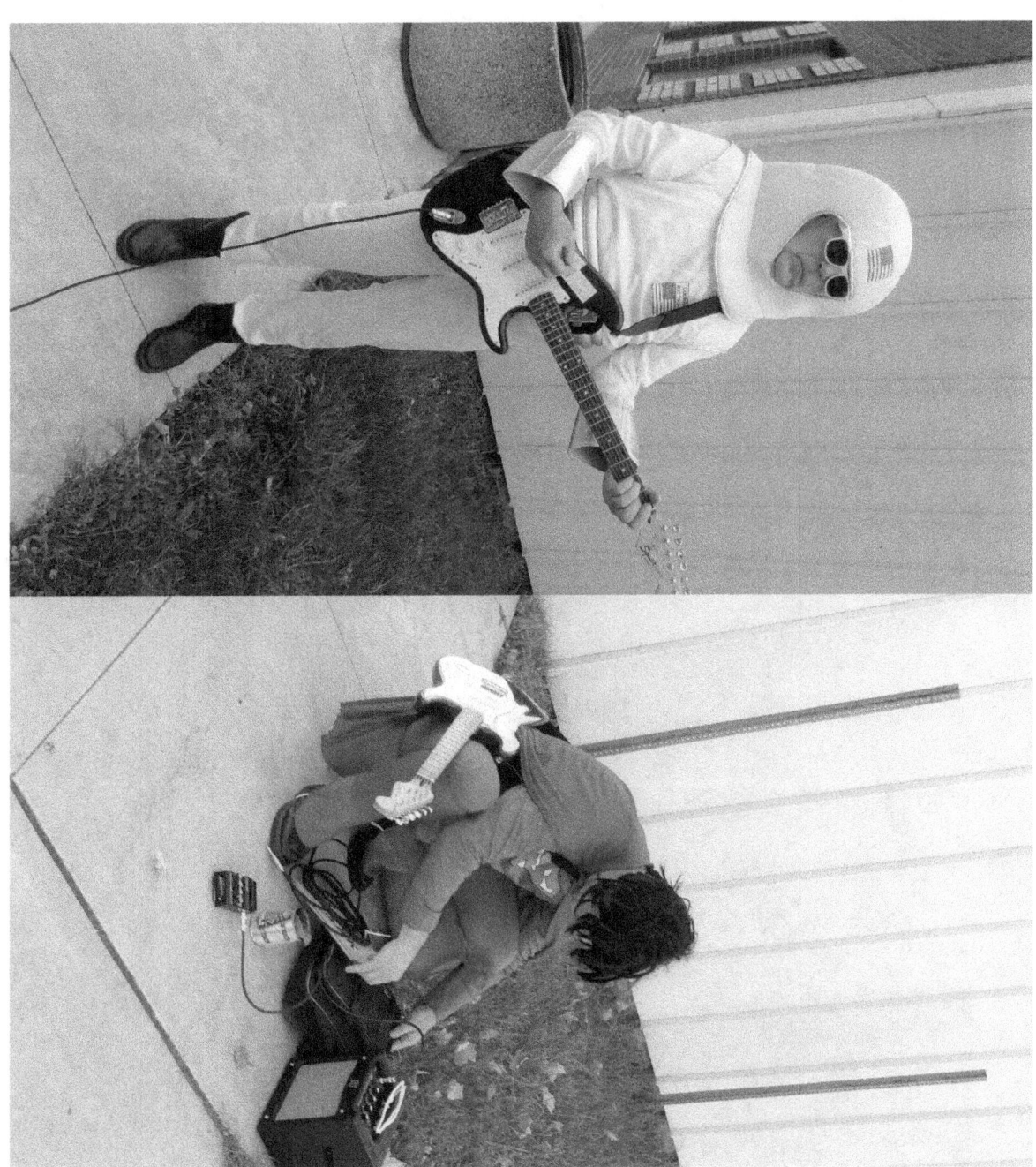

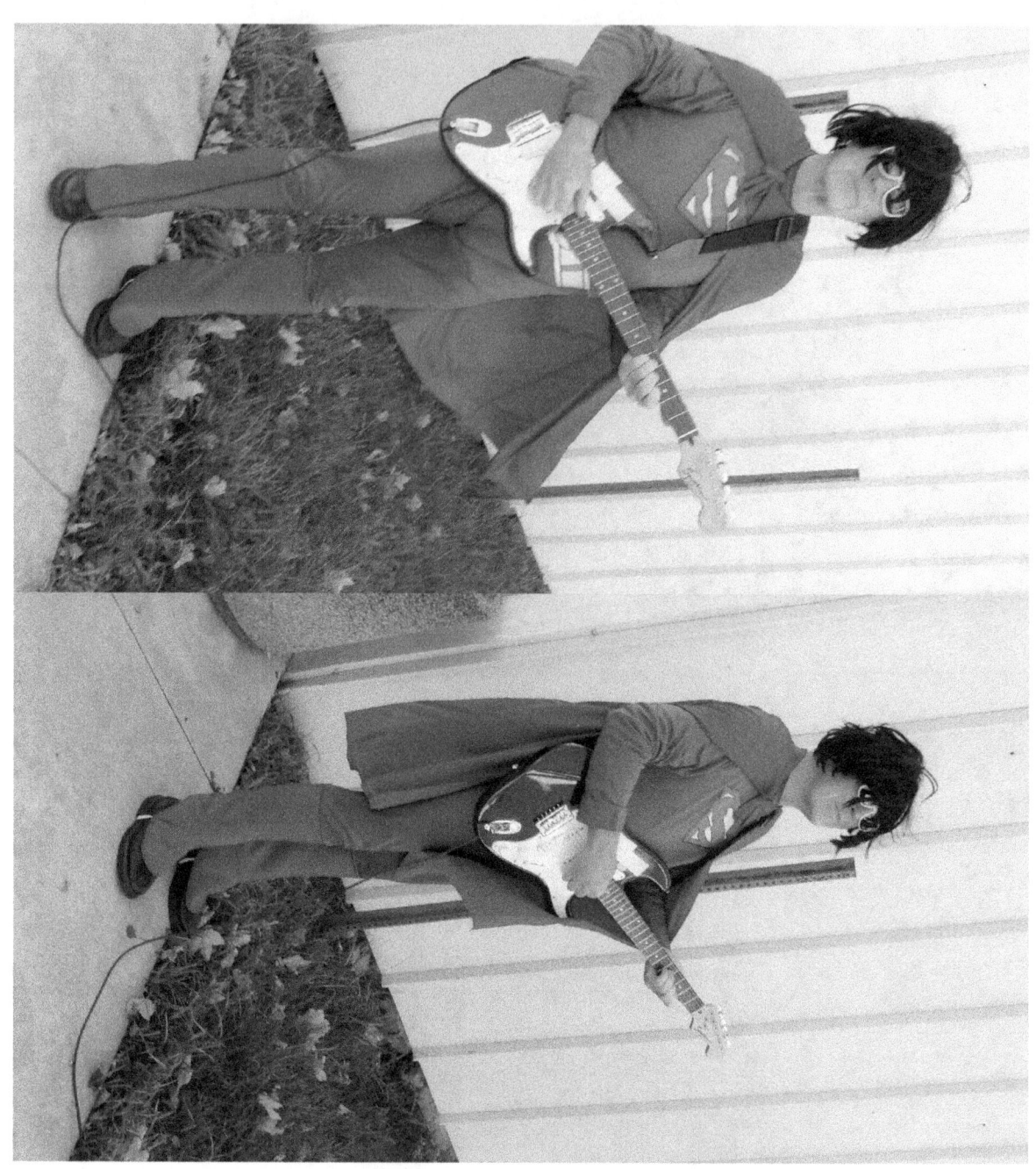

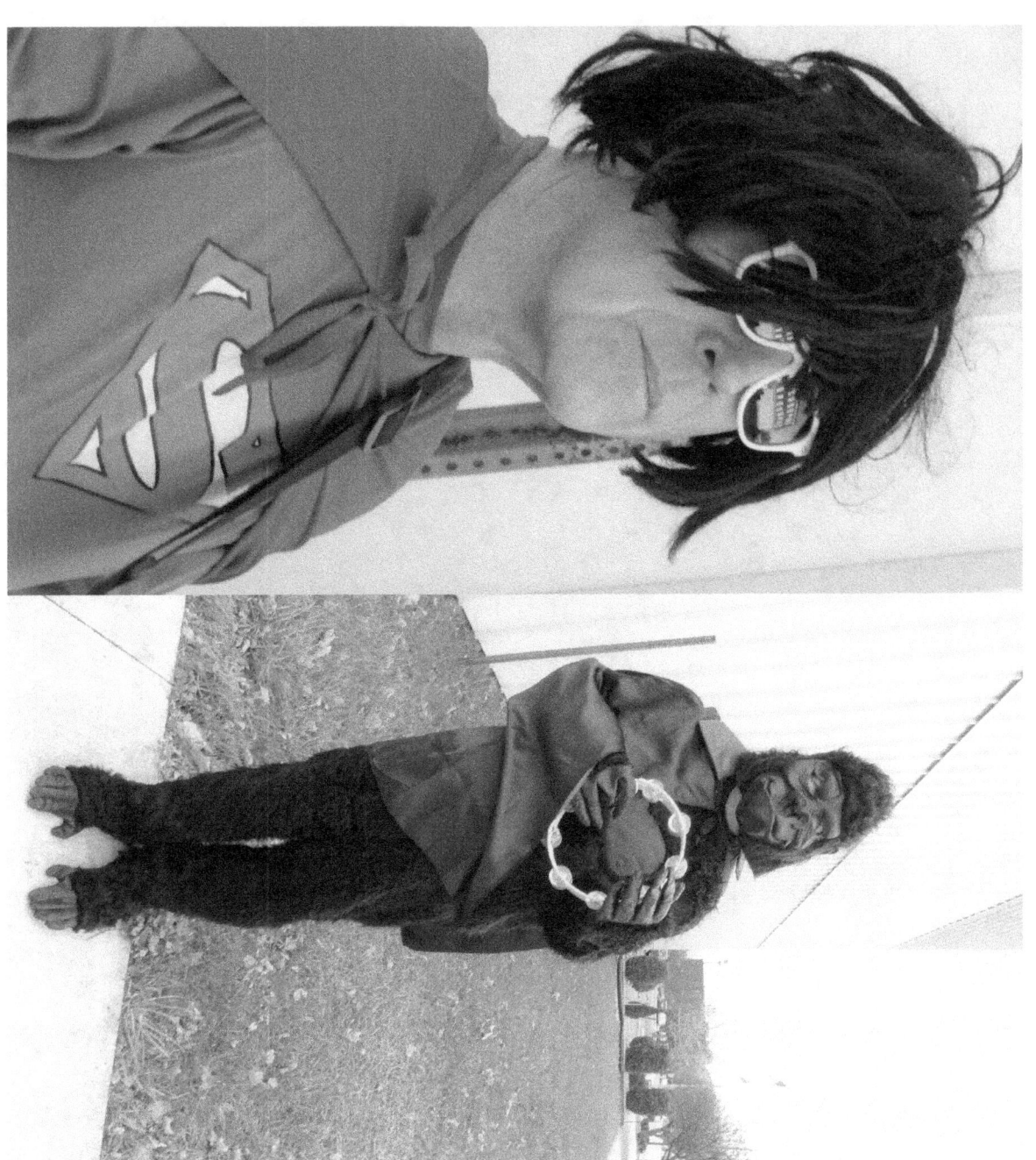

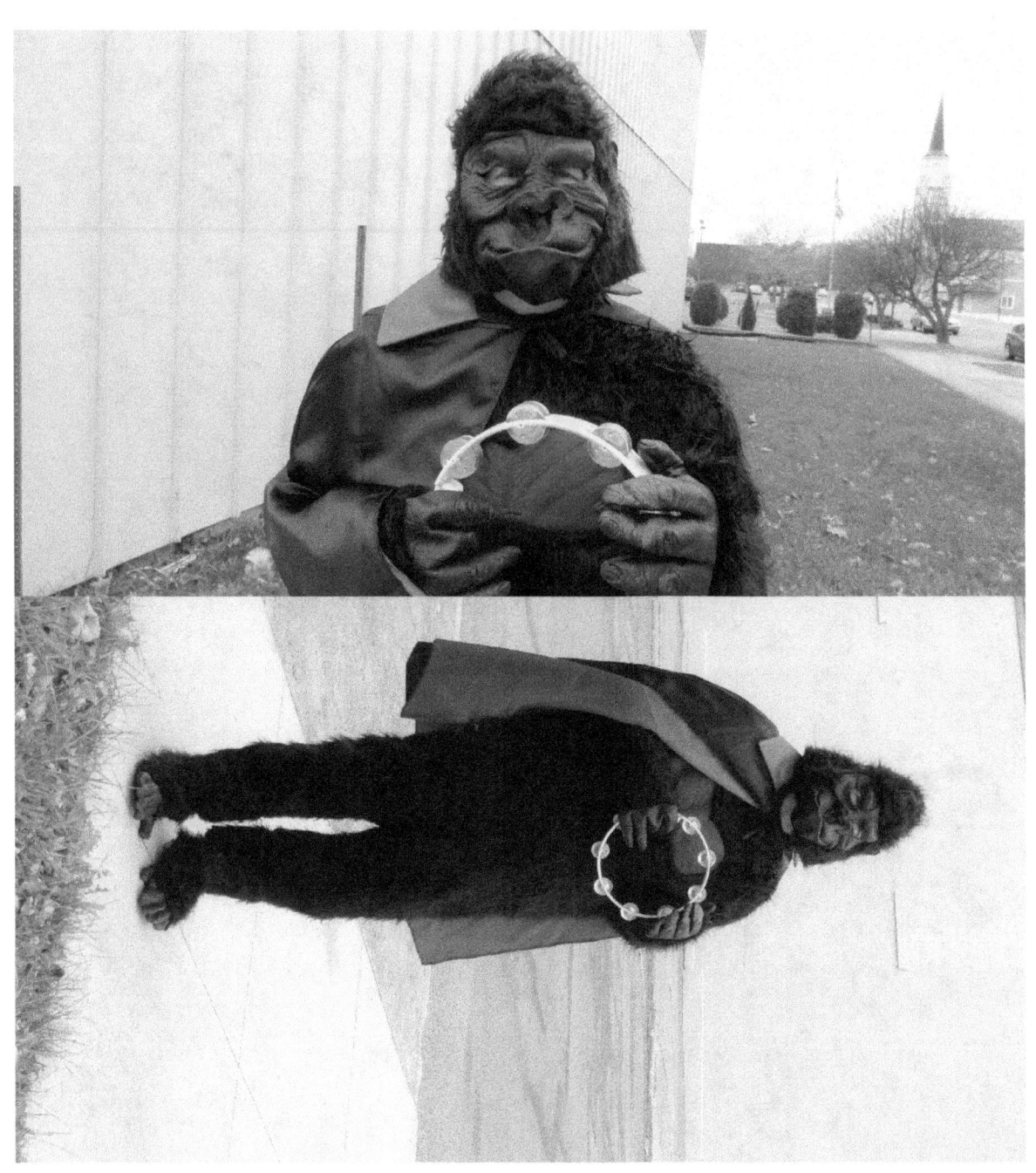

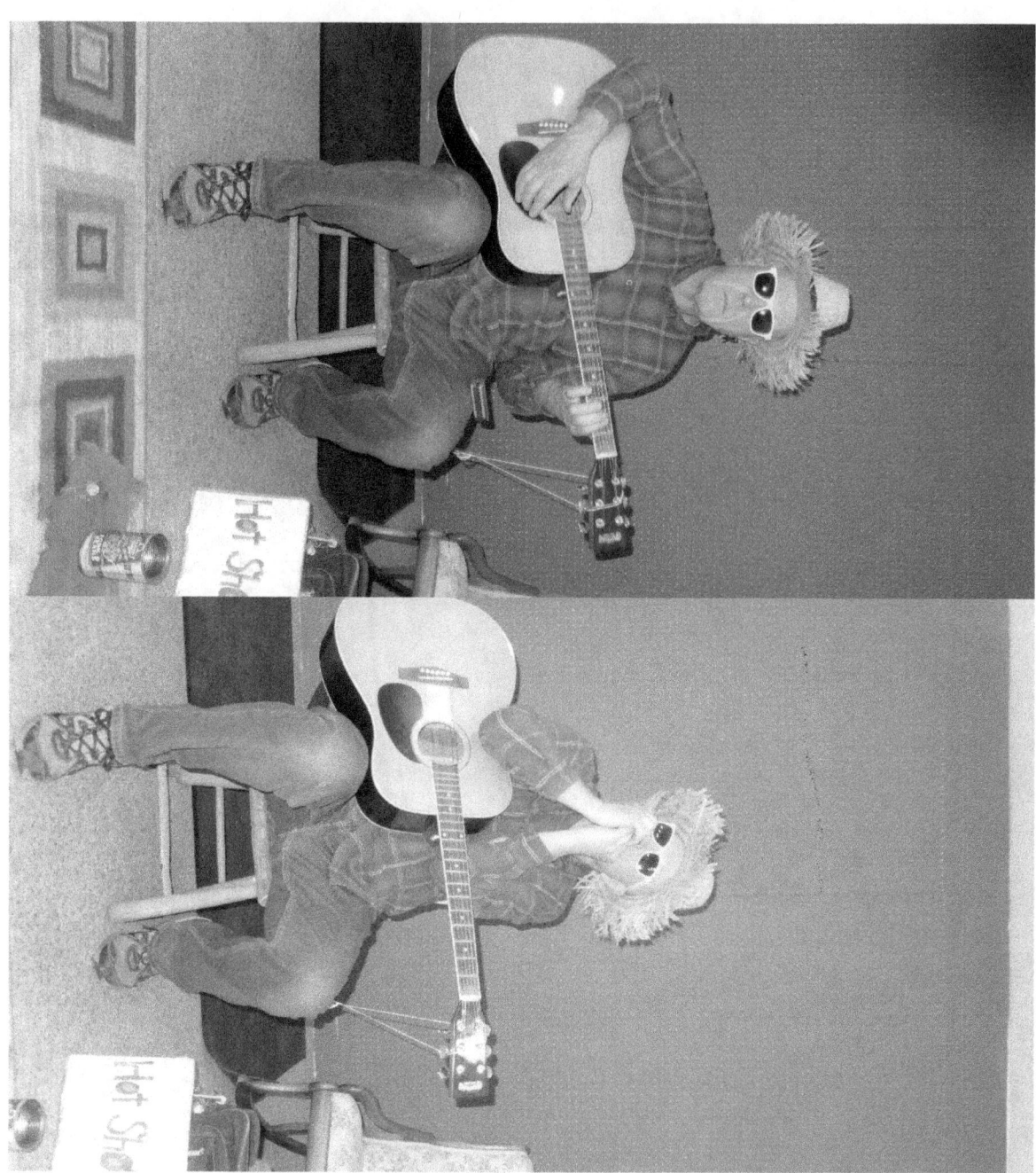

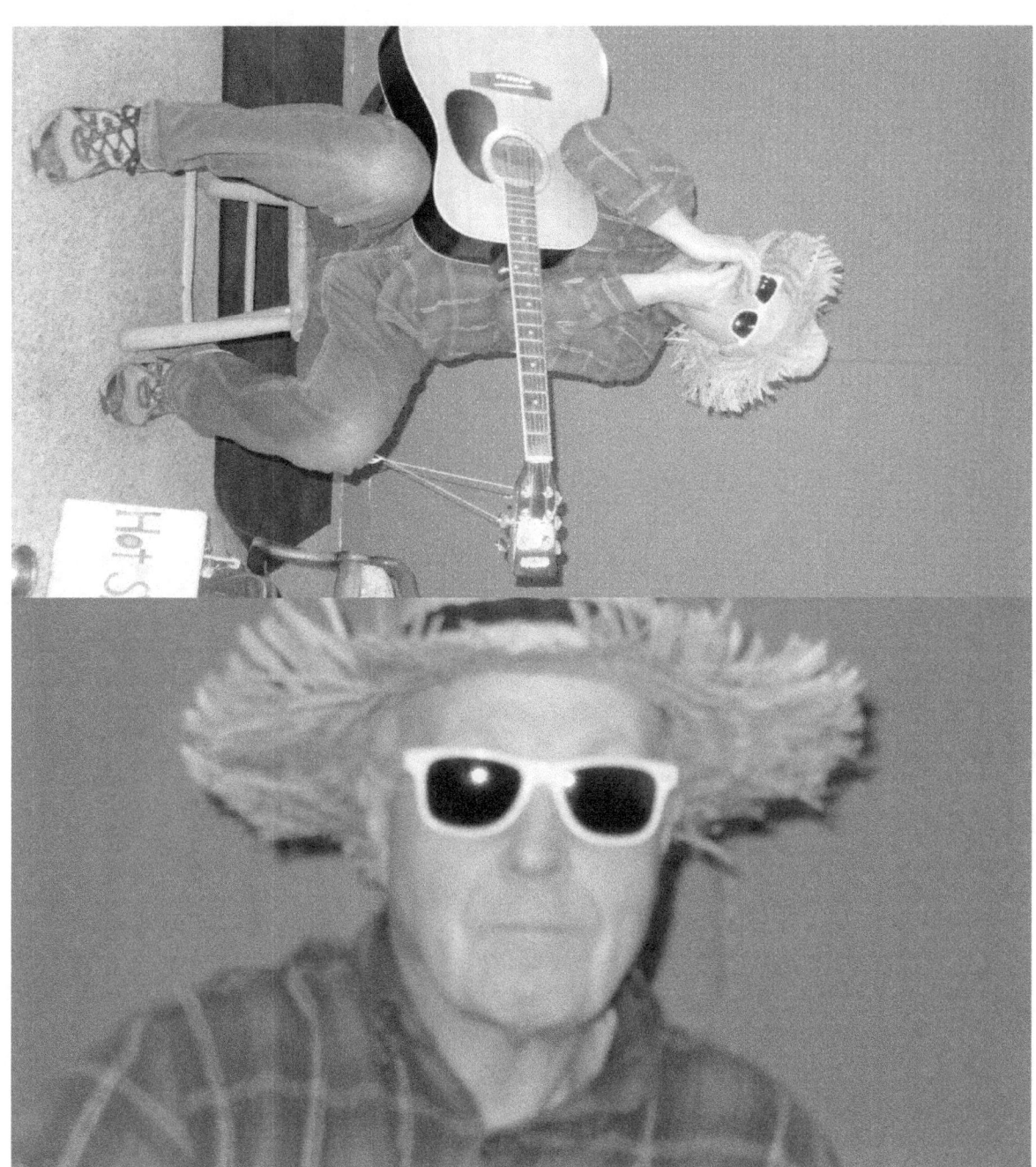

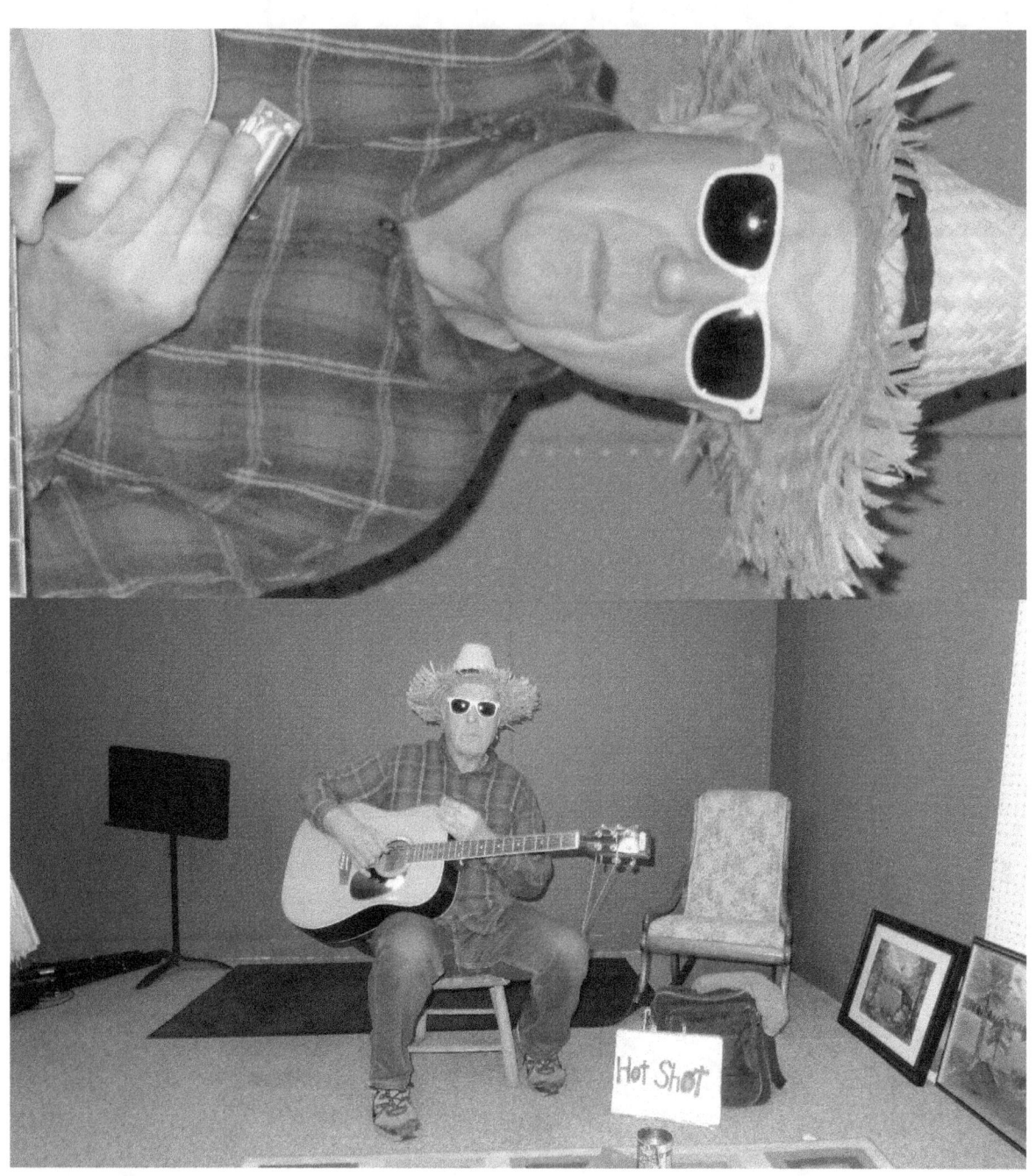

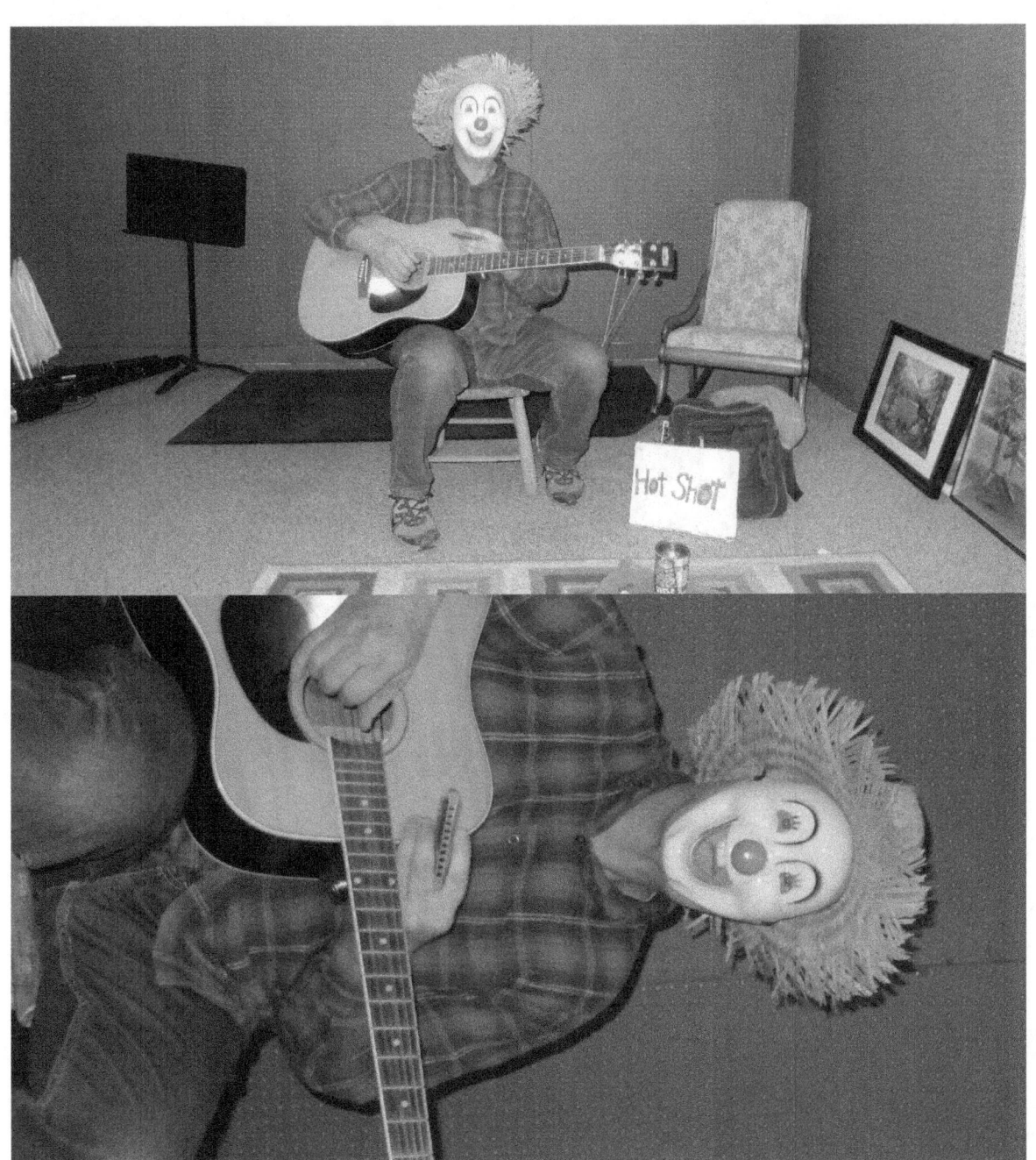

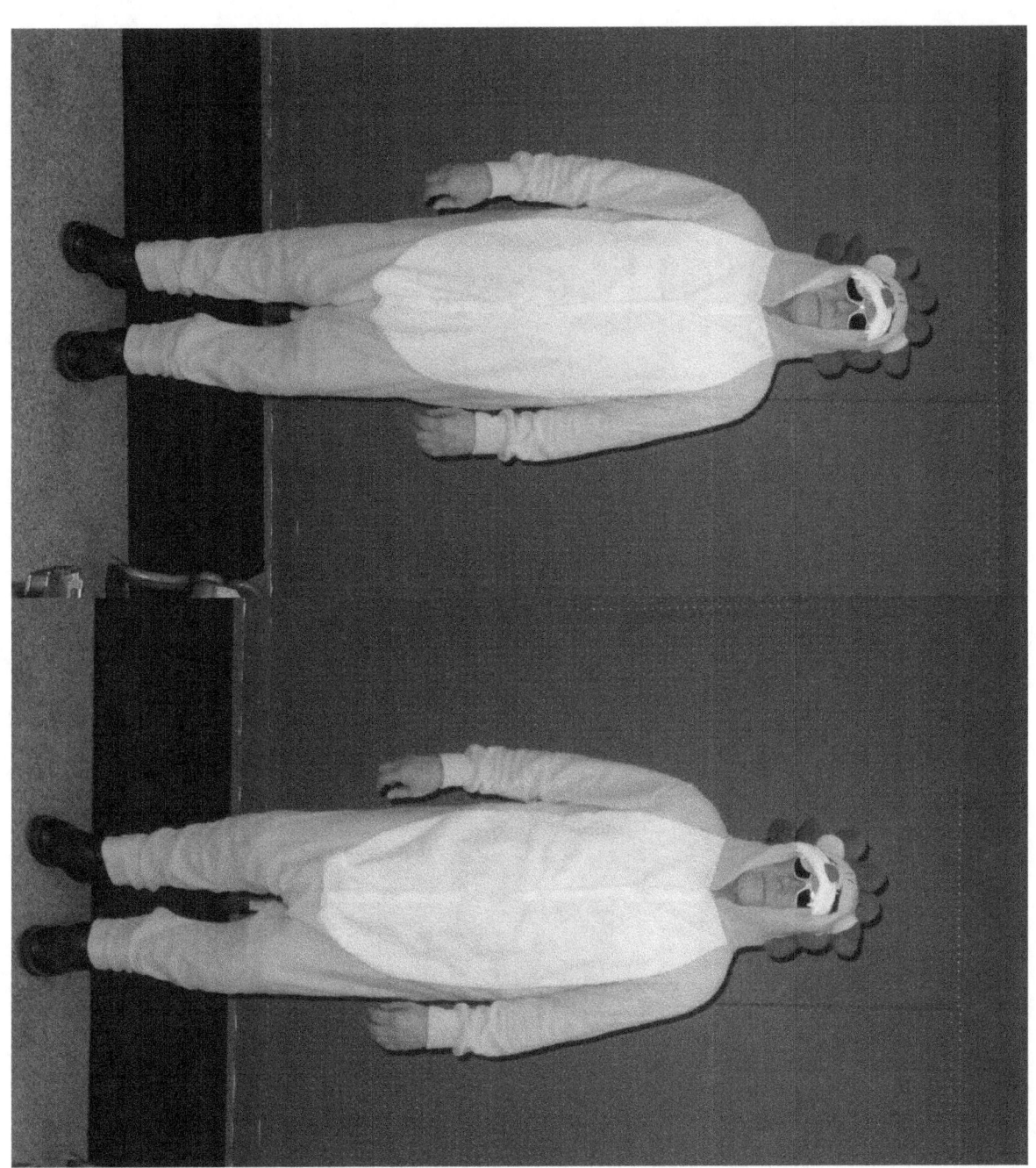

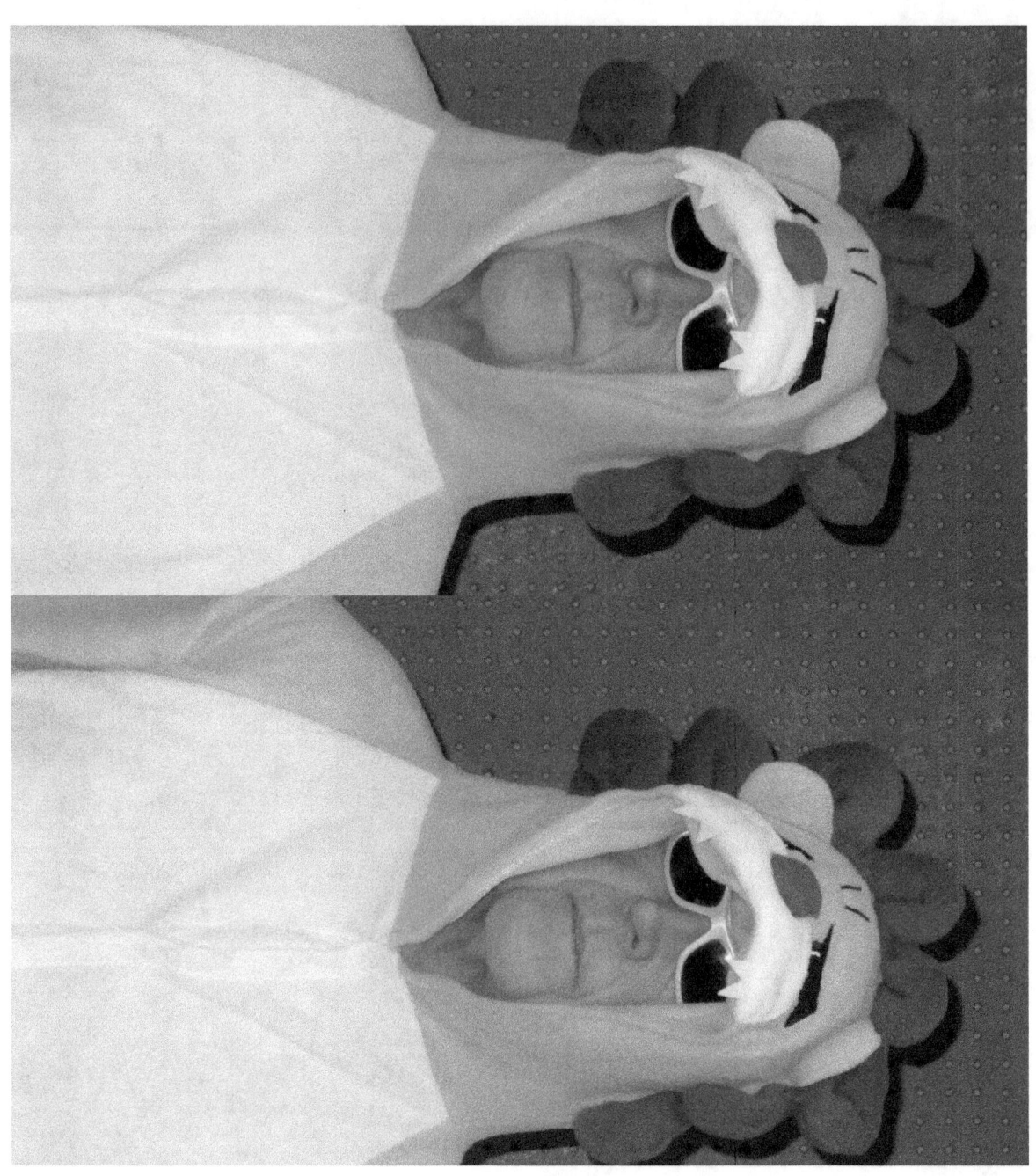

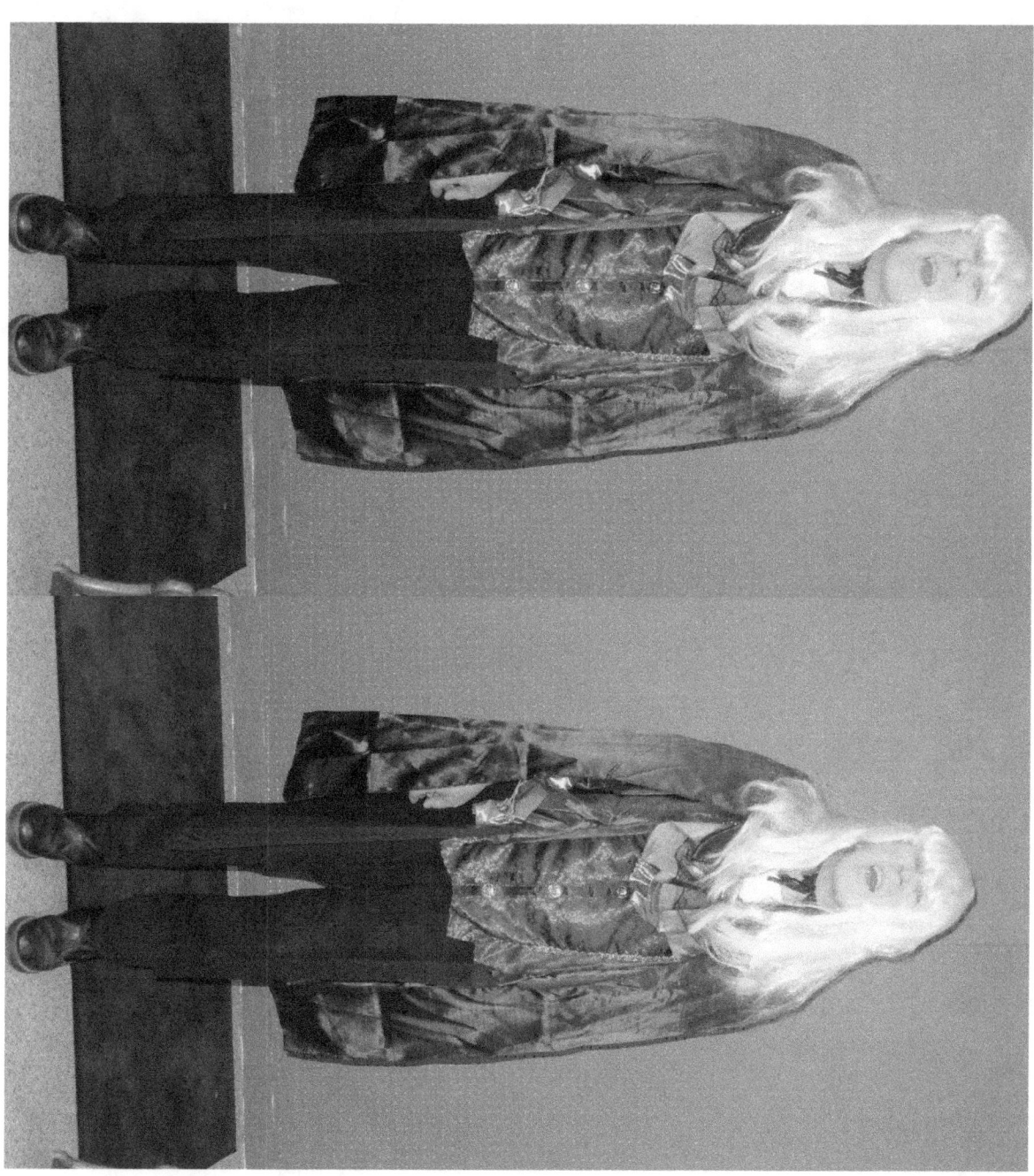

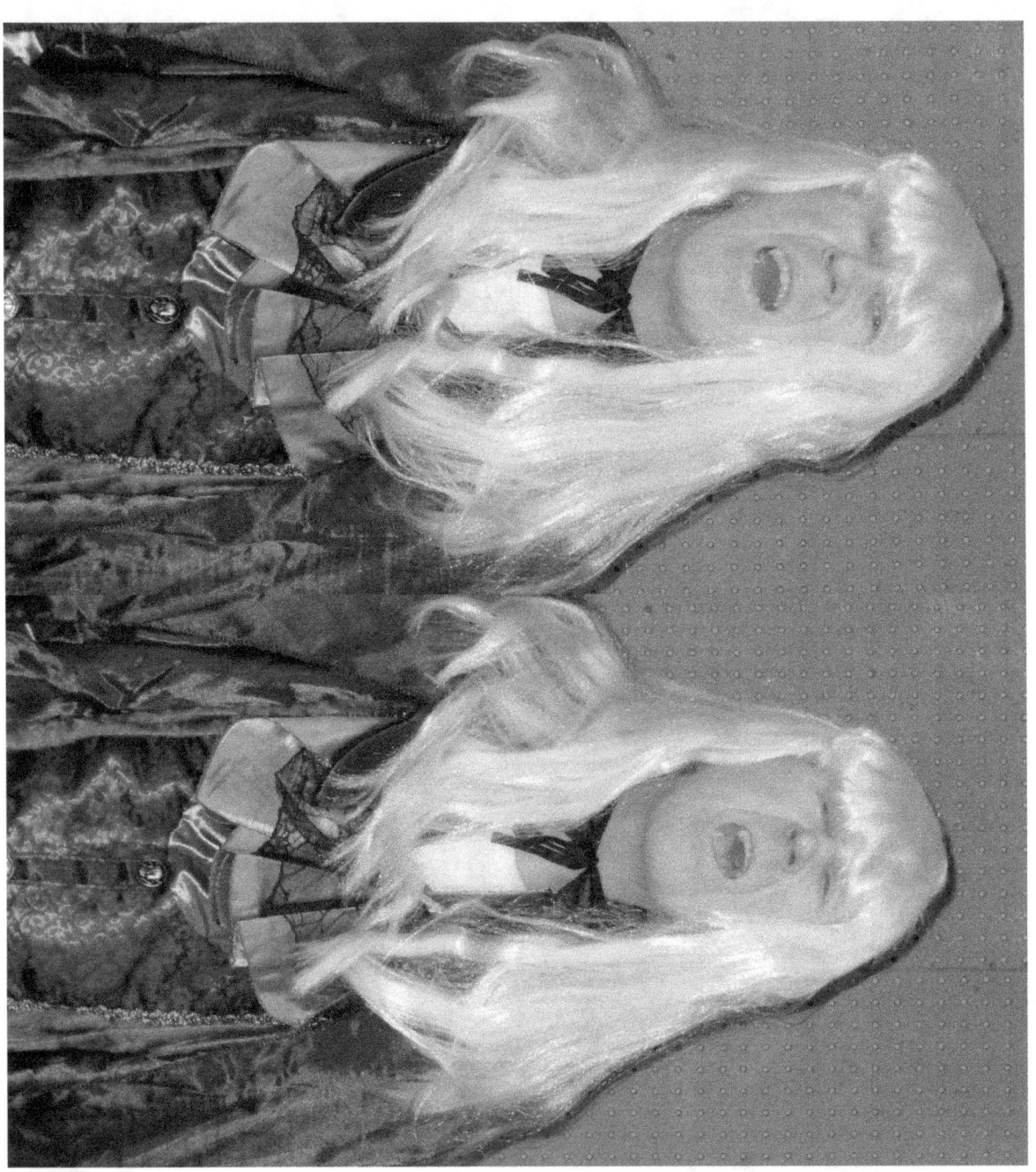

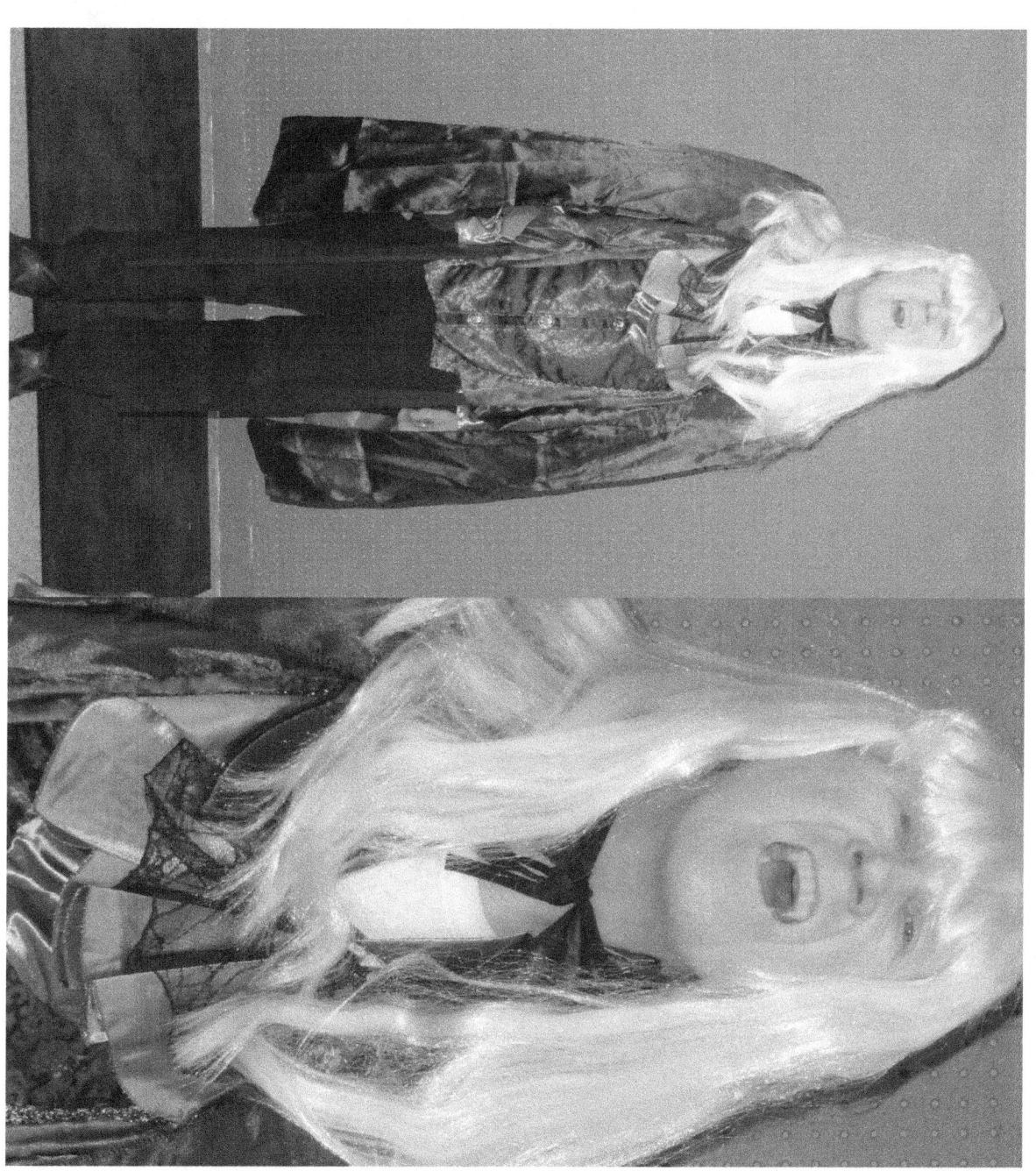